# Directions

## REALLY GOOD ADVICE FOR GETTING FROM HERE TO THERE

Hallie Bateman

workman publishing
new york

Library of Congress Cataloging-in-Publication Data is available.

ISBN 978-1-5235-1005-4

Design by Becky Terhune

Workman books are available at special discounts when purchased in
bulk for premiums and sales promotions as well as for fundraising or
educational use. Special editions or book excerpts can also be created
to specification. For details, contact the Special Sales Director at
specialmarkets@workman.com.

Workman Publishing Co., Inc.
225 Varick Street
New York, NY 10014-4381

workman.com

WORKMAN is a registered trademark of Workman Publishing Co., Inc.

Printed in China
First printing February 2021

10 9 8 7 6 5 4 3 2 1

# Introduction

My mother says there are two kinds of people: Alive people and Not Alive people. *Alive* people are engaged in the act of living, attuned to others, present in the moment, and "a little bit shiny." *Not Alive* people, on the other hand, "exhibit an almost spiritual dullness." They are dampened, muted, and view life at a distance.

I'm an Alive person, according to my mother. I agree with her, because I desperately want to be an Alive person. And because I feel like an Alive person—most of the time.

When I feel Not Alive, it's usually because I am focused too much on the future or the past. I am numb to the present moment. Walking around my neighborhood, I'll blow right past the jasmine bushes without picking up their scent. When I'm Not Alive, every precious, fleeting moment is a chore to be endured.

Because I'm a visual thinker, it helps me to take notes and refer to them often. I need to be reminded to take deep breaths, that this is all temporary, that strawberries exist (!!), that there are stars in the night sky—even in a big city—and I should look up now and then and allow the universe to dwarf me. When I remember these things, I'm electrified Alive, back to believing there is undeniable worth in the human endeavor.

That's how *Directions* began. This book is a touchstone to my own Aliveness, and I hope it will become one of yours, too. There are a lot of jasmine bushes out there, waiting patiently to be sniffed.

Do not
take these
directions
to be Literal,
all-encompassing,
OR Fitting in
every context.

If you don't
know what
someone's
talking about,
ask.

Little by little, become yourself.

Articulate what you love about the ones you love.

Go to the bathroom as SOON as you wonder if you have enough time to go.

Empathize with
Caution,
practice
compassion
with abandon.

Correct
people
who call
you "lucky."

Do not
buy a pet
if you can
rescue one.

# Excuse yourself and tend to yourself.

Saying "Drive Safe" magically shields any person you say it to from getting in an accident, so say it to everyone, all the time.

know that
terrible and
wonderful things
will befall you,
regardless of
your anxiety
and yearning.

Do not
use "balls"
to mean
toughness.

The testes
are extremely
sensitive.

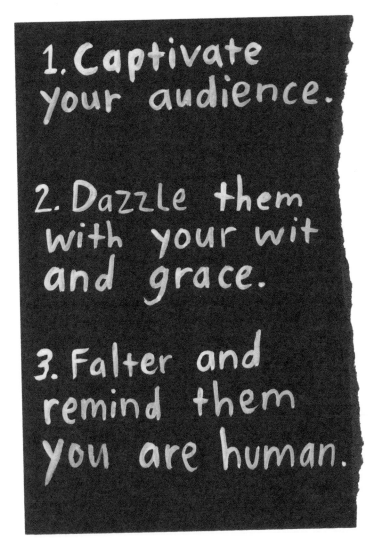

1. Captivate your audience.

2. Dazzle them with your wit and grace.

3. Falter and remind them you are human.

If it ever
occurs to you
to buy flowers,
buy them. It's
never a bad
idea.

Dress yourself in colors that make your eyes pop.

Remember that the likely explanation for the symptom you self-diagnosed as an obscure cancer from reading WebMD at 1 a.m. is: **Bodies are weird.**

Think about
what you'll
miss most
when you're
dead.

Do more
of that.

Repeat a word
until it makes
you Laugh.

School school
School school
School school
School school
School school
School school

One possible
solution to
this <u>dire, urgent</u>
<u>Problem</u> is to
go to bed and
deal with it
in the morning.

Dream bigger. Bigger. Bigger. BIGGER.

if
and
when
you can,

vote.

1. Do <u>NOT</u> be embarrassed.

2. Not even of that.

3. NOT EVEN OF <u>THAT</u>!

Require decency
of your friends,
no matter how
Long you've known
them.

Dispense advice if it's asked FOR. Otherwise, dispense Love.

Dance and encourage dancing but don't force anyone to dance.

think about
how proud your
past self
would be if
they could see
you now.

THiNK about
death enough
to appreciate
life, but not
so much that
so much that
it eclipses
Life.

treat
children
like human
beings.

But also
like children.

APPLY LOTION REGULARLY AND GENEROUSLY.

GET OLD ANYWAY.

Look hard for
your talents.
Consider all
things: parallel
parking, ability
to peel an
orange in
one go, etc.

let
other
people
be
other
people.

Be Kind
to customer
service workers
on the phone.

Firm, but kind.

when you have a flash of memory, don't run from it and it won't run from you.

write down your daydreams, night dreams, and things you say in conversation.

(sometimes making art is just paying attention.)

Travel far distances to see old friends.

TALK TO YOURSELF SWEETLY, LIKE YOU'D SPEAK TO A SCARED CHILD.

ISSUE FORGIVENESS GENTLY AND EASILY.

There are
many kinds
of beauty
and your kind
is one
of them!

Look up.

(What do you see?
what do you hear,
smell, feel?)

Isn't it fun to
be alive?

Thank the people who listen to you talk about your **dreams.**

Conjure specialness from thin air. Invent holidays, traditions, and surprises. (Duck Day, Ice Cream Tuesday, etc.)

Eating your feelings is fine. Just be sure to explicitly state, "I am going to eat my feelings."

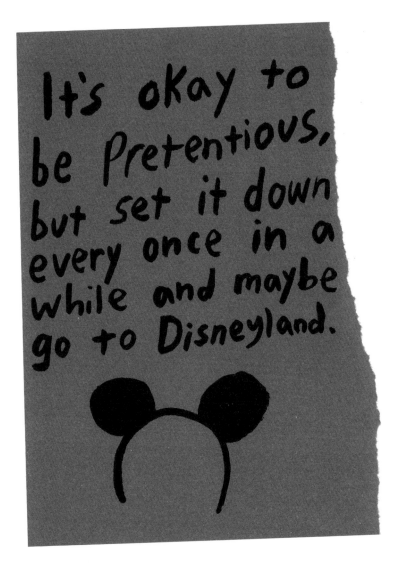

It's okay to be pretentious, but set it down every once in a while and maybe go to Disneyland.

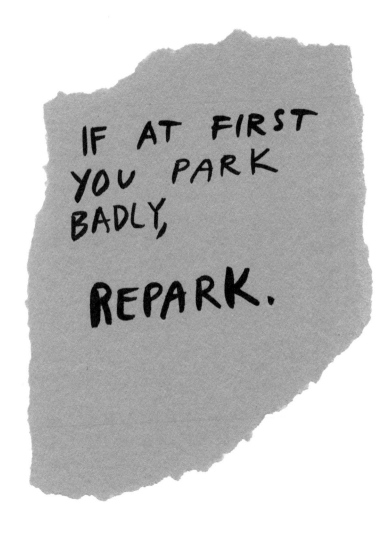

IF AT FIRST
YOU PARK
BADLY,

REPARK.

keep the exclamation points in your email. What the hell, add a smiley face!

☺

# MAKE New Friends:

- through other friends
- through common interests
- on the street
- on the internet
- through one person being brave
- no matter how many friends you have
- no matter how old you are

Try Not
to drool
but don't
beat yourself
up if it
happens.

Do not be afraid or jealous of hot people. They are just people who happen to be hot.

avoid
anyone who
is more
than 2.8%
cruel.

Go Left

then right

then down
the middle

eat the whole
pan of brownies.

If you're lying awake imagining art you want to make, get out of bed and make it.

When you meet someone from somewhere, ask if they know the one person you know from there. It's worth a shot!

Give up
on
finding
Love.
In one way
or another,
it will
find you.

Learn to read maps, recipes, and instruction manuals. Or don't, and take pleasure in making those around you feel truly needed.

Don't let their wanting it stop you from giving it to them.

WHen embarking on an anxiety-induced spending spree, make sure you grab a few self-help books.

If you find yourself obsessing about everything you don't have, give something away to someone who needs it more.

Identify the types of privilege you benefit from. Work through the shame and fear and <u>educate</u> <u>yourself</u>.

When it's good,
try, **try** to
enjoy it.

**Things are
allowed to
be good.**

Imagine the person you
want to be with. List
their qualities, hair color,
likes/dislikes, etc.

Then keep
an eye out.

Consider that you might be wrong and correct course.

ALLOW PHOTOS OF YOURSELF TO EXIST IN THE WORLD, IF ONLY FOR FUTURE FRIENDS WHO WILL WANT TO SEE ALL THE LIVES YOU LED AND/OR HAIRCUTS YOU HAD.

If you change your outfit more than three times, it's not gonna happen today. Just wear:

1. all black

2. overalls

3. pajamas and don't leave the house.

When people ask you
how you are,
tell them how you
REALLY are
so they'll tell you
how THEY really are,
unless you don't care
how they really are,
in which case
it's fine to say "fine."

Reevaluate your set of established Likes every couple of years, just in case you Like _____ now.

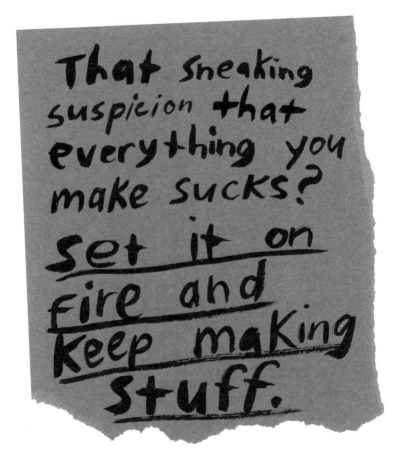

That sneaking suspicion that everything you make sucks?

set it on fire and keep making stuff.

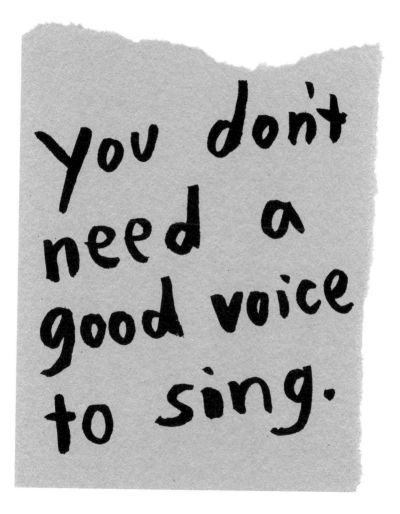

Let the people you love the most tell the stories they love to tell, even if you've heard them before.

For everyone else, politely stop them mid-sentence.

EVERYONE ON TV IS TERRIBLE AT RELATIONSHIPS.

DO NOT LEARN FROM them.

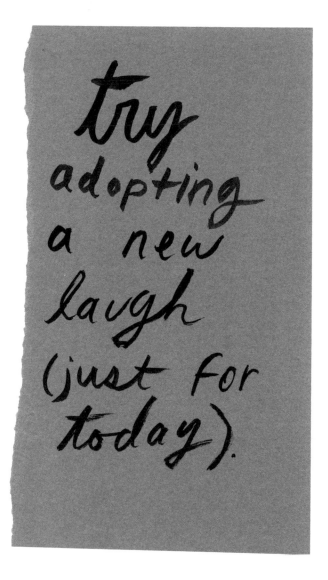

try adopting a new laugh (just for today).

Remember that your partner should get you through the hard times. Your partner shouldn't BE the hard times.

Be creative with first dates, so even if it's horrible, you at least did something interesting.

Ideas:

- Take a cemetery stroll.

- Visit a cheesy tourist attraction in your town.

- Do an arts and crafts project together.

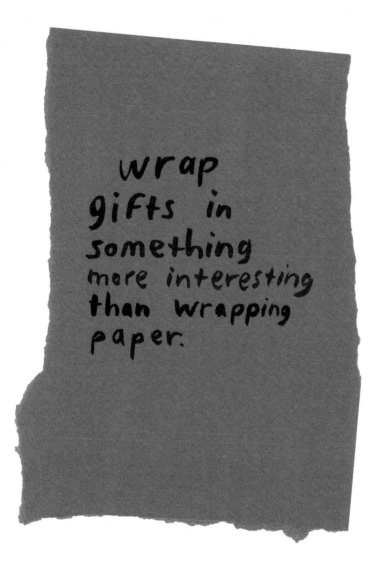

wrap
gifts in
something
more interesting
than wrapping
paper.

KEEP a list
of names
you like. You
never know
when you'll
need to name
something.

If the person you love wants to stay through the movie credits, find a way to enjoy it even though you want to stand up. Give them this.

Let your default be something besides "stressed."

When someone
you know is
grieving,
overcome
your discomfort
and reach
out.

When the desire to write has left you, give it five more minutes.

Ask new friends about their friends.

Learn about their little universe of love and admiration, and you will become a part of it.

eat.

Let dogs
lick you.

say goodbye with gusto each time, just in case.

# When you are feeling jealous of someone,

1. admit you are jealous.

2. pinpoint what is making you feel jealous. Do you want to attain something, or are you afraid of losing something?

3. take this as confirmation of what you truly want, and adjust accordingly.

Treat it as sacred and it will become sacred.

Go ahead,
try to be clever.

It's fun!

keep
your old
journals,
no matter
how
embarrassing.
they are
evidence of progress.

Take pride
in being the
least frustrated
person at the
airport, in
traffic, at the
DMV, etc.

Listen to
yourself
when you
talk.

Live with people who already love you and will easily forgive you for accidentally breaking their teacup.

It's fine if you're too lazy to work toward your dreams but if you're scared, get over it.

Respect
the natural
world and
it may
tolerate us
for a bit
longer.

Alter the lighting of a familiar space. Make it groovy.

you do
not need
to be
inebriated
to have
the time
of your
life.

Accept rejection as a grand indication that you're trying.

Don't be tricked into thinking it's virtuous to be outdoorsy. You are allowed to enjoy sleeping indoors.

when people say "this could be a book!" listen to them. Make it into a book.

FOCUS less
on what you
liked/disliked.
What did you
<u>NOTICE</u>?

Attend all weddings you are invited to, unless:

1. you truly do not value the friendship and don't want it to continue, or

2. You absolutely cannot afford to travel for it.

When complaining, consider why. Is it because you...

A. actually want something to change?

B. just want support and affirmation?

C. love to complain?

Then, warn those around you so they know whether to offer help, chime in, or tune out.

SAY THANK YOU WITH DETAILS.

EXAMPLE:

"I know you worked very hard to learn how to beat that Donkey Kong level. Thank you for sharing that **knowledge** with me."

Take a
moment to
be glad you
are not in
middle school.

(Unless you are
in middle school, in
which case, I'm sorry,
it will get so much
better, you're doing great.)

Be frugal,
but splurge on
a few daily joys
(creamer for your
coffee, brand name
Q-tips, etc.).

ask your
friends their
favorite
colors
and
remember.

You might
die soon,
or they
might die.
Or we
all might.
Make peace and
hold each other close.

# Index

# Acknowledgments

Thank you to my wonderful agent, Kate McKean, for your smart advice and guidance through the process of making this book. Thank you for harboring me in your safe, warm little corner of the publishing world.

Thank you to Megan Nicolay, Sarah Curley, Becky Terhune, Dylan Julian, and the rest of the incredibly talented team at Workman who worked through a time of immense national turmoil to bring this book into the world. Megan, I believe you saw this book more clearly than I did when we first started working together. Thank you for sharing your vision with me. I'm so grateful for your careful editing and all the time and consideration you put into our collaboration.

Jack Sjogren, I will never forget jumping up and down on the hotel bed with you during our honeymoon when we found out this book was going to be published. It is a joy to live alongside you. Thank you for sharing your incredible tastes in music and art with me. For making art with me. And for making me laugh-cry as often as you do. I know I am in the best of all possible worlds because we are married.

Jacqueline Suskin, you knew what this book was from the very start. Thank you for your encouragement, your thoughtful discussion, and your editing. I am spoiled to have access to your rare, exquisite form of genius. Thank you for hosting me at your beautiful home in the forest while I worked on this book, and for smoking tons of weed with me while I was there.

Thank you to Alice Medland, for being exactly who you are. You saw me when I needed to be seen, and helped me become who I am. Your encouragement has steadied me again and again on my path to becoming (and staying) an artist. Thank you for teaching me lessons that I used in this book, my favorite of which is "If it ever occurs to you to buy flowers, buy them. It's never a bad idea."

To my mom, Suzy Hopkins, thank you for lending me the idea that wound up being the introduction to this book. You are part of everything I write, not just because you are my editor, but because you taught me how to write. You are the most fun person to tell good news, big or small, and I am so grateful to get to celebrate every little achievement with you. I love you.

To my dad, Chris Bateman, I am so grateful for your love and support and encouragement. Your belief in me has taught me to believe in myself. You also taught me, by your inquisitiveness, to be inquisitive. And it's so fun to be inquisitive! Thank you. I love you.

To my brothers, Nick and Ben, thank you for talking on the phone with me multiple times a week. Nick, I love you. I treasure our freaky creative

bond and am so grateful for your friendship. Ben, thank you for taking my phone calls in which I just beg you for advice. I can't help it. You give great advice. Because you're a great big brother. I love you.

Marge Othrow, I will never get over our fortuitous meeting. That experience directly inspired the direction on page 56. Thank you for letting me into your beautiful life. I absolutely adore you.

Thank you to the many friends who talked, walked, laughed, and ate with me in the years in which this book was made. Thank you for teaching me lessons that wound up in this book. Especially Ariana Lenarsky, Hallie Cantor, Dan Gutterman, Jo Livingstone, Marian Bull, Blythe Roberson, Adia White, Rosy Hao, Devon Picklum, Lily Blake-Shepherd, Amanda Lake, Sofia Lacin and Keith Ochwat, Michael Cochran, Joge and Jessie Medofer, Jeff Pianki, Laura Sjogren, Yelena Sofia, Emily Henry and Joey Cook, Ashley Eva Brock, Felicity Porter, Mitzvah Mitzowitz, and Spinelli.

Megan Jayne Crabbe, your book *Body Positive Power* was pivotal in my eating disorder recovery. While making this book, I used my brain to think about things that actually matter instead of calories. Thank you for liberating me.

Thank you to the countless artists whose work has inspired me, and whose influence I see in this book. Especially Lynda Barry, Lydia Davis, Miranda July, Adam J. Kurtz (who told me "love is real" years ago and I'll never forget it), David Shrigley, Jonathan Richman, Yoko Ono, and Amy Krouse Rosenthal.

# About the Author

Hallie Bateman is a writer and illustrator based in Los Angeles. She is the author of *Brave New Work* (MoMA, 2016) and *What to Do When I'm Gone* (Bloomsbury, 2018). Her work has been featured in the *New York Times*, the *New Yorker*, Buzzfeed, and other publications. She can be found on Instagram and twitter @hallithbates. More of her work can be found at halliebateman.com.